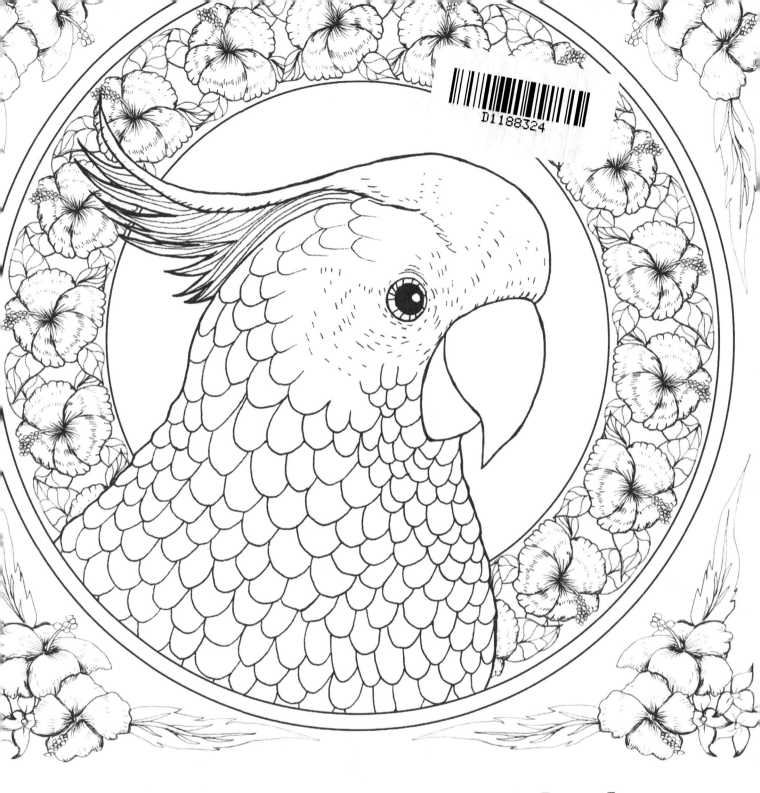

Art Nouveau Birds

A Stress Relieving Adult Coloring Book

illustrated exclusively for Blue Star Coloring by
Maysa Sem

Blue Star

Teamwork makes the dream work

Illustrator
Maysa Sem

Design & Production
Chris Ramirez
Tommy Barros
JP Garrigues
Peter Licalzi

Publishing & Operations
Brenna Dominguez
Clare Burch
Kiersten Blair
Reagan Lewis
Camden Hendricks

Illustration by
Tyler Fisher

This book belongs to:

..

Show us your art...
We'll show the world.

/bluestarcoloring

for free prints, updates, & more visit
bluestarcoloring.com

@bluestarcoloring

@colorbluestar

We'll never be perfect, but that won't stop us from trying. Your feedback makes us a better company. We want your ideas, criticism, compliments or anything else you think we should hear!

Oh, and if you don't love this coloring book, we'll refund your money immediately. No questions asked.

Send anything and everything to contact@bluestarcoloring.com.

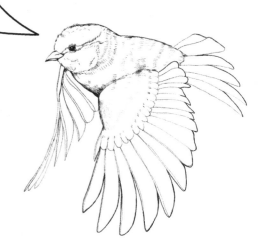

How to Use This Book

1 Break out your crayons or colored pencils.

2 Turn off your phone, tablet, computer, whatever.

3 Find your favorite page in the book. That is the beginning.

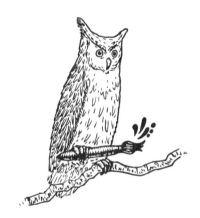

4 Start coloring.

5 If you notice at any point that you are forgetting your worries, daydreaming freely or feeling more creative, curious, excitable, delighted, relaxed or any combination thereof, take a deep breath and enjoy it. Remind yourself that coloring, like dancing or falling in love, does not have a point. It is the point.

6 When you don't feel like it anymore, stop.

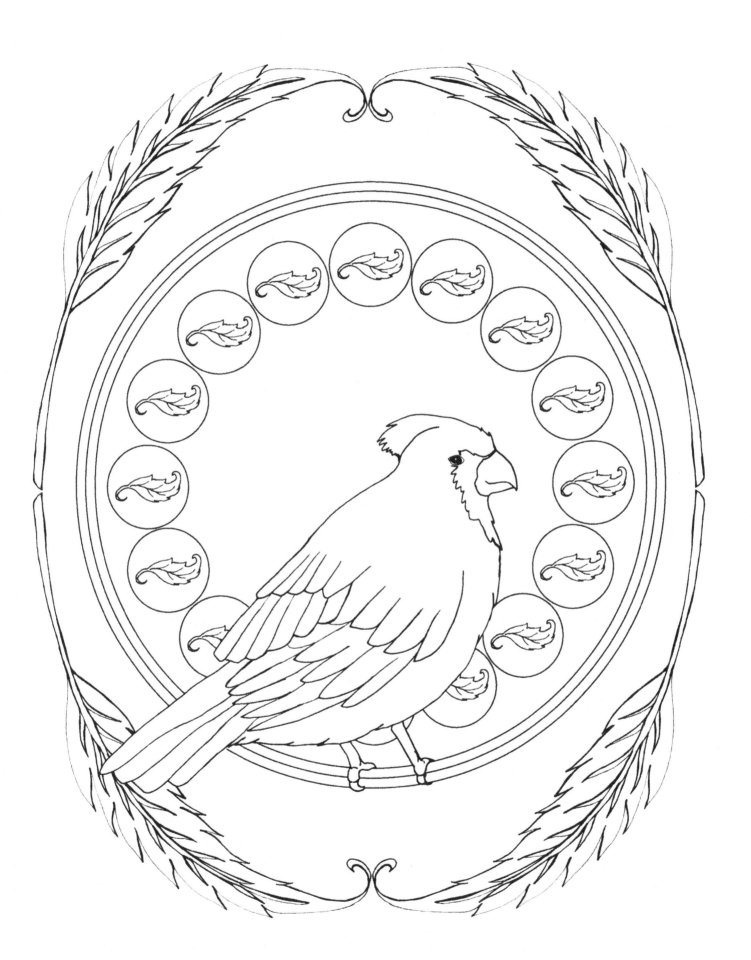

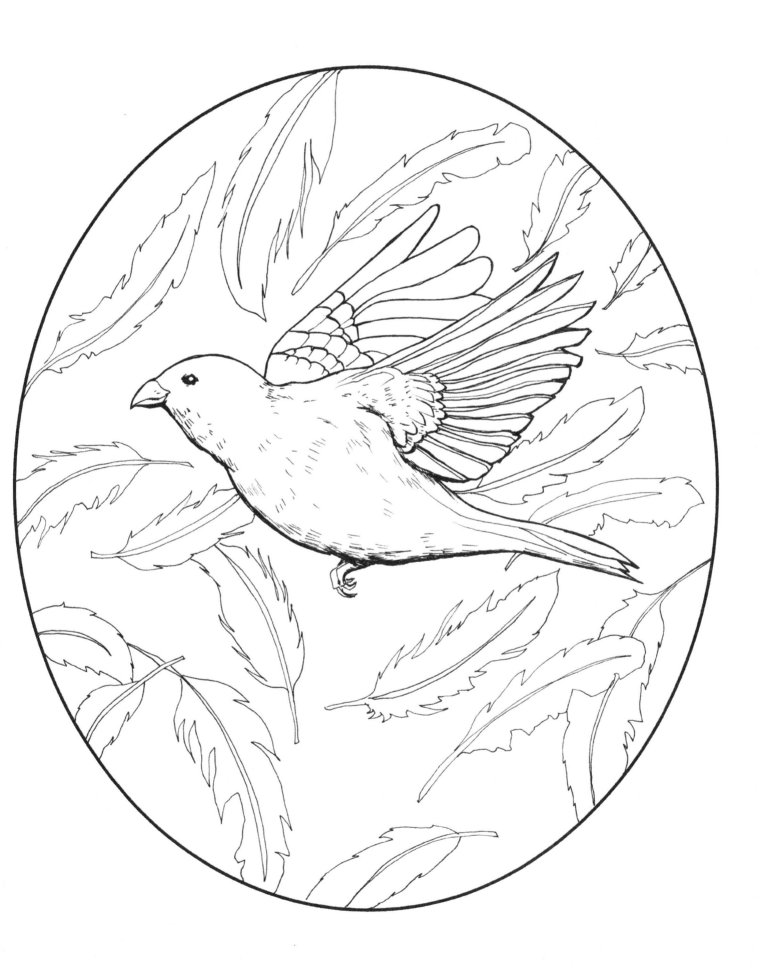

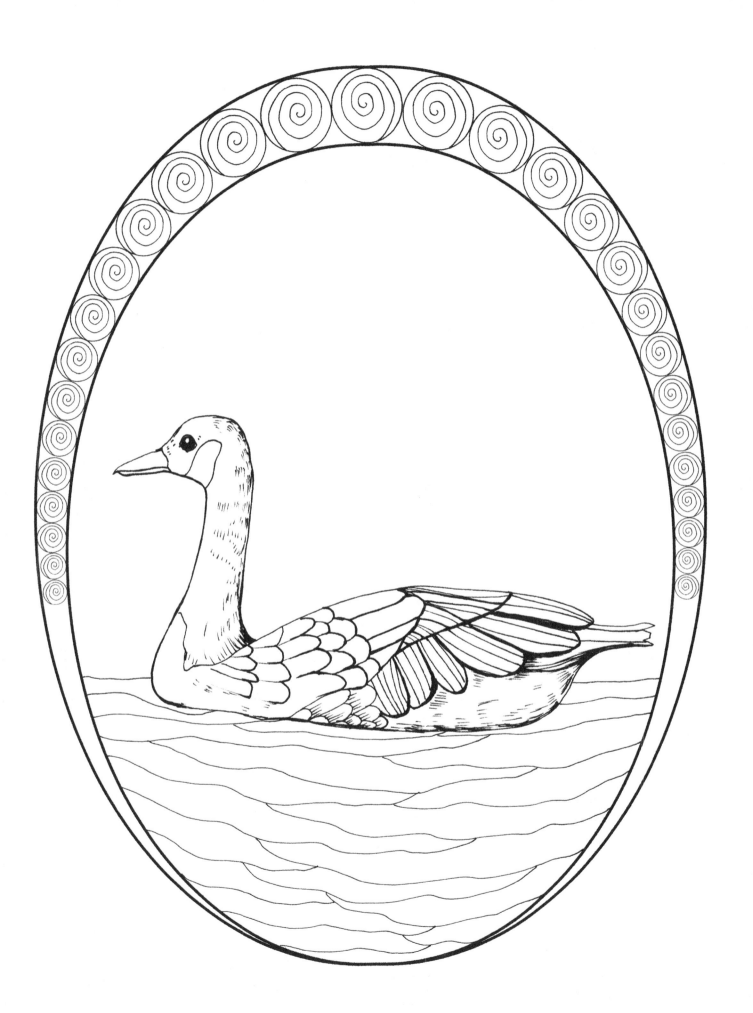

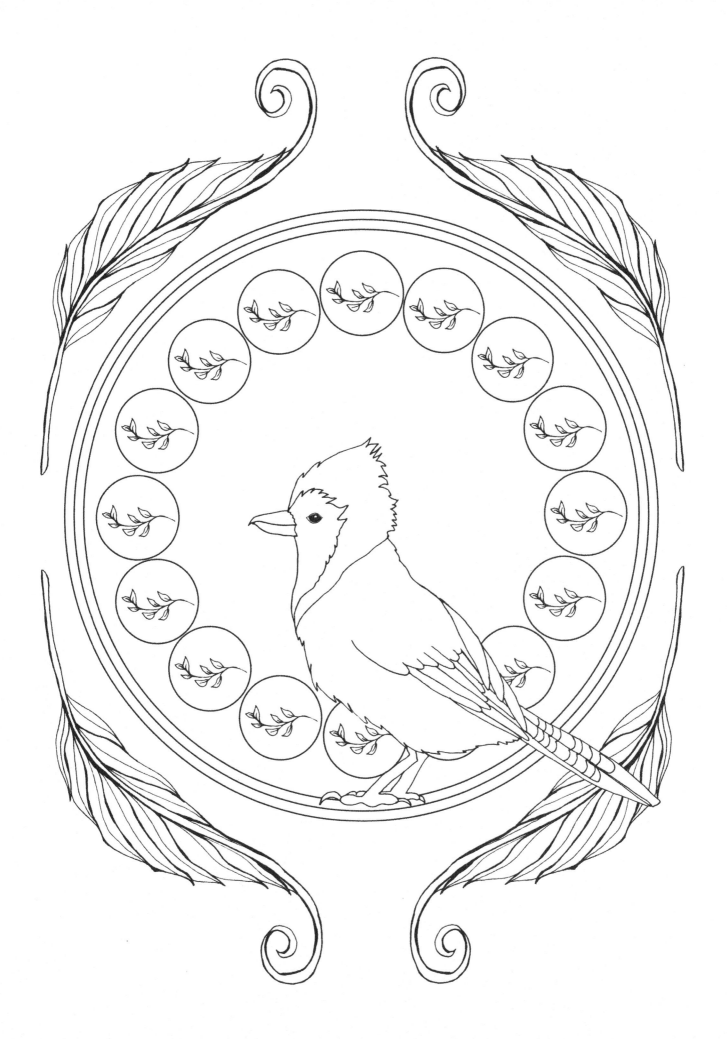

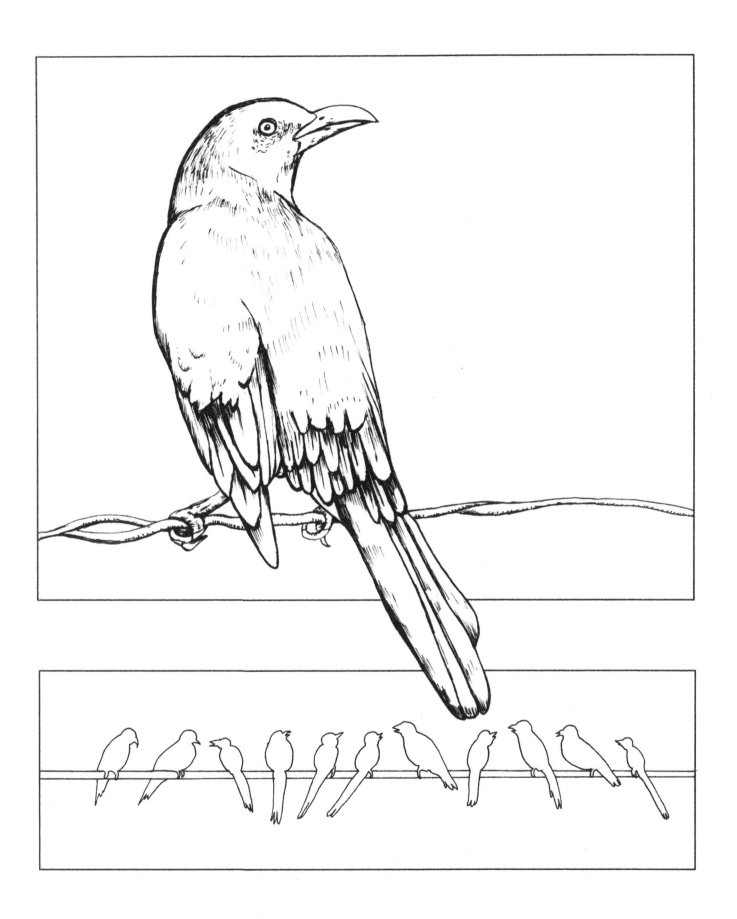

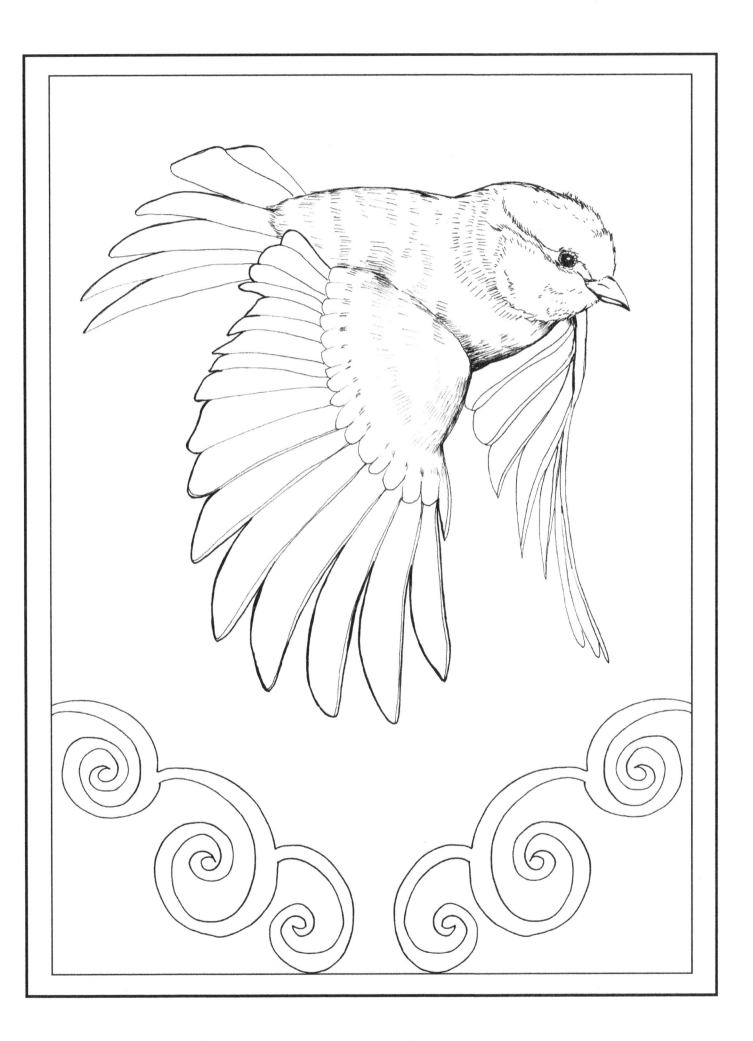

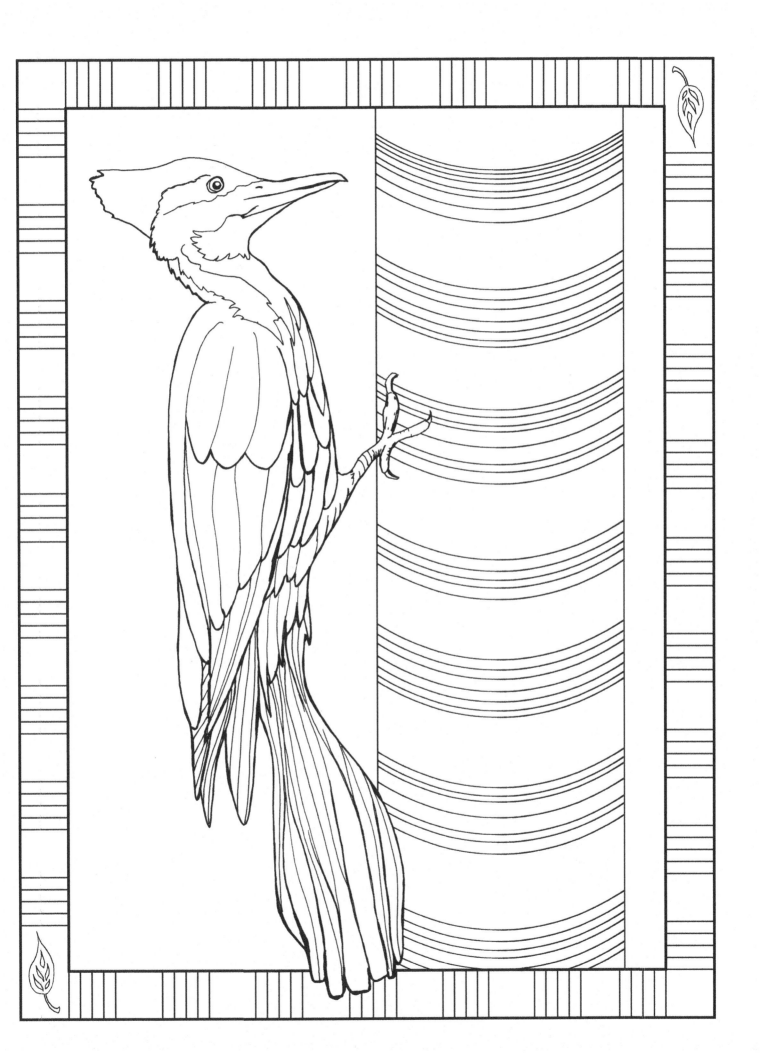

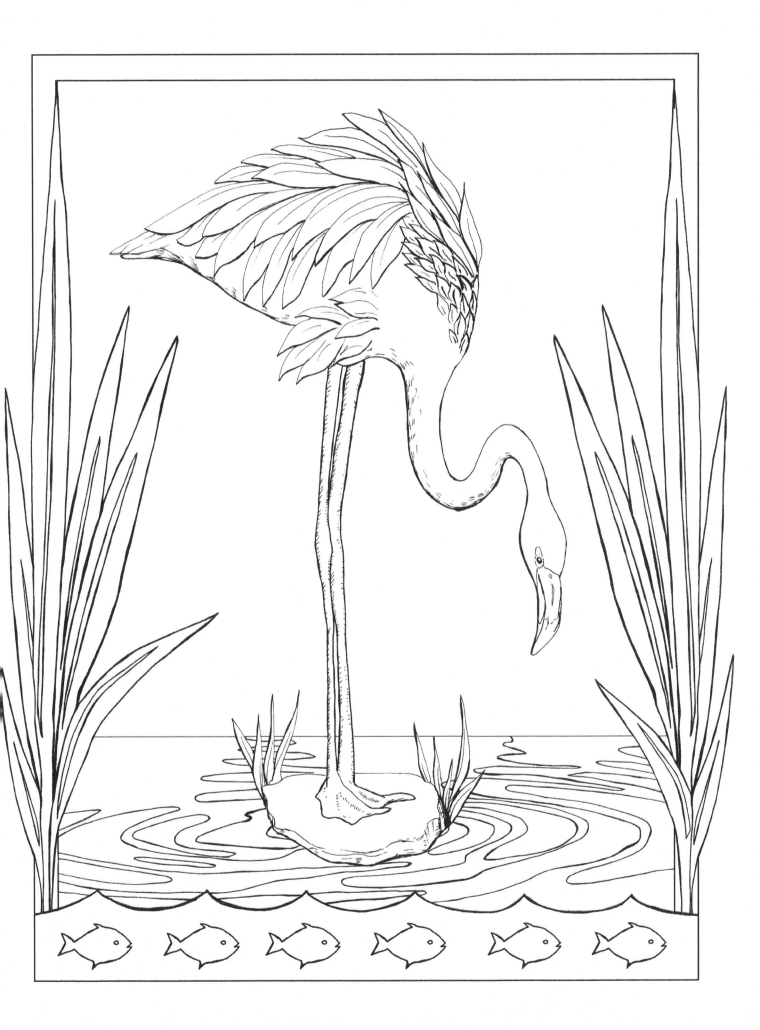

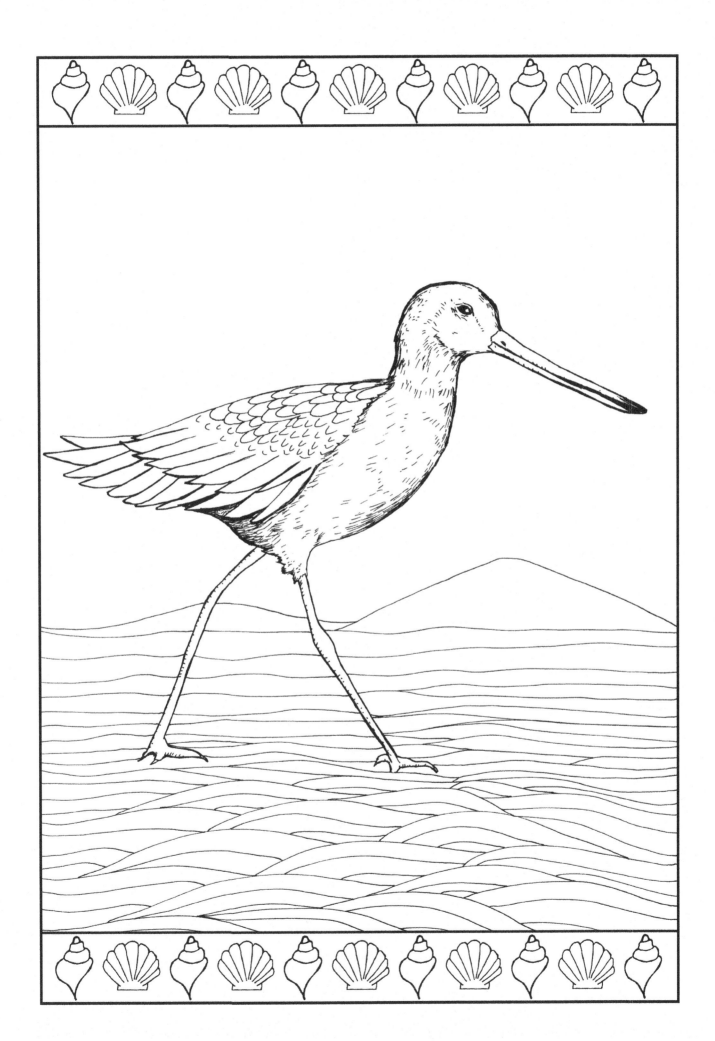

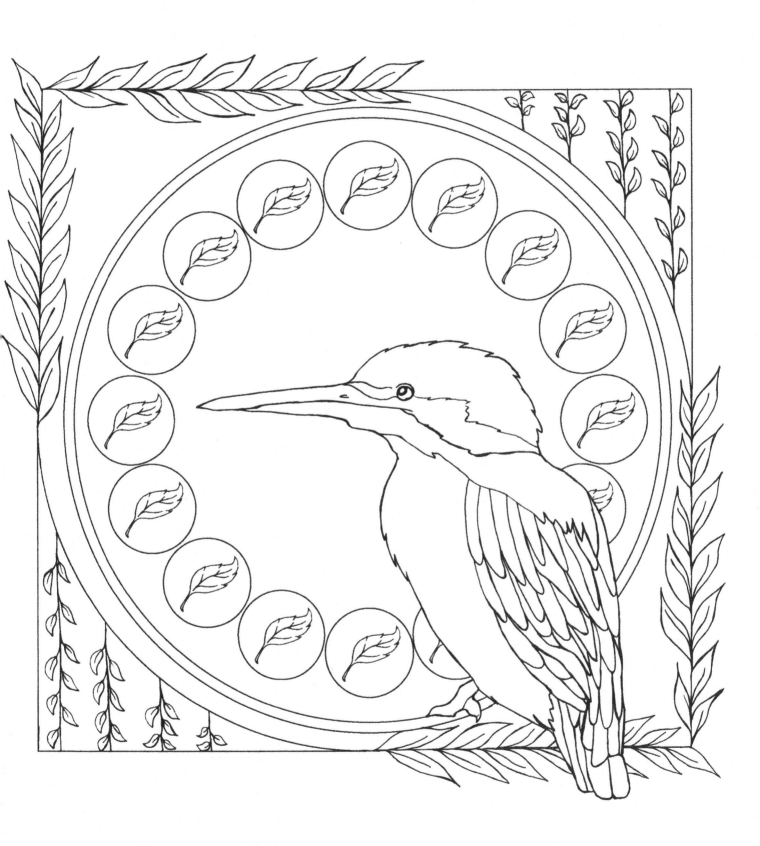

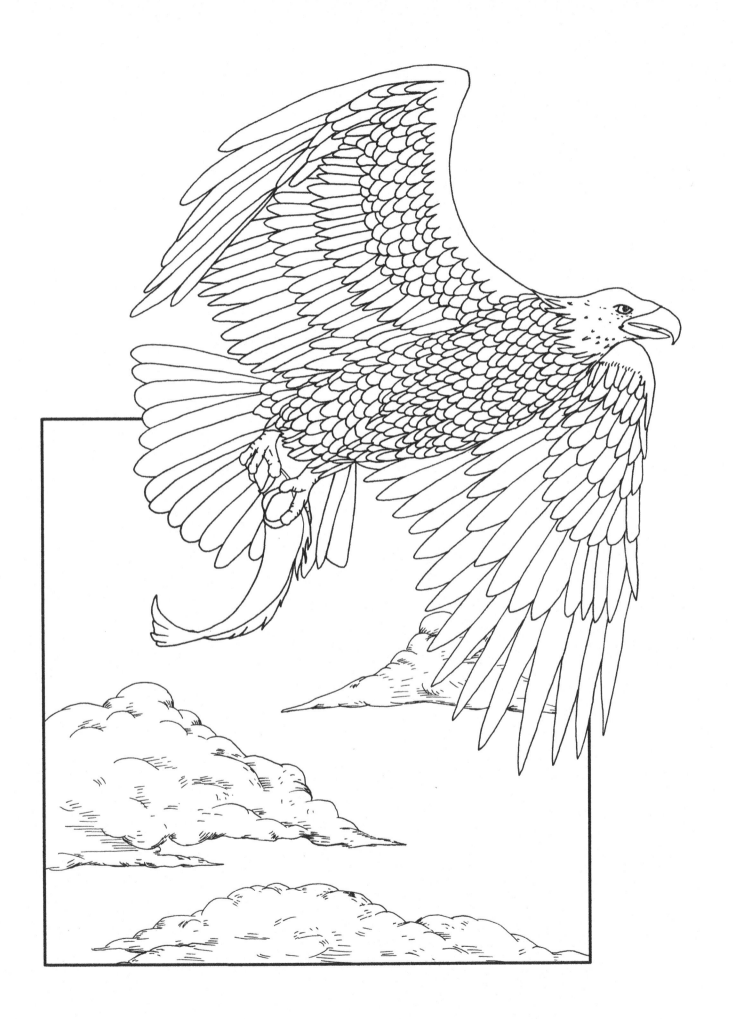

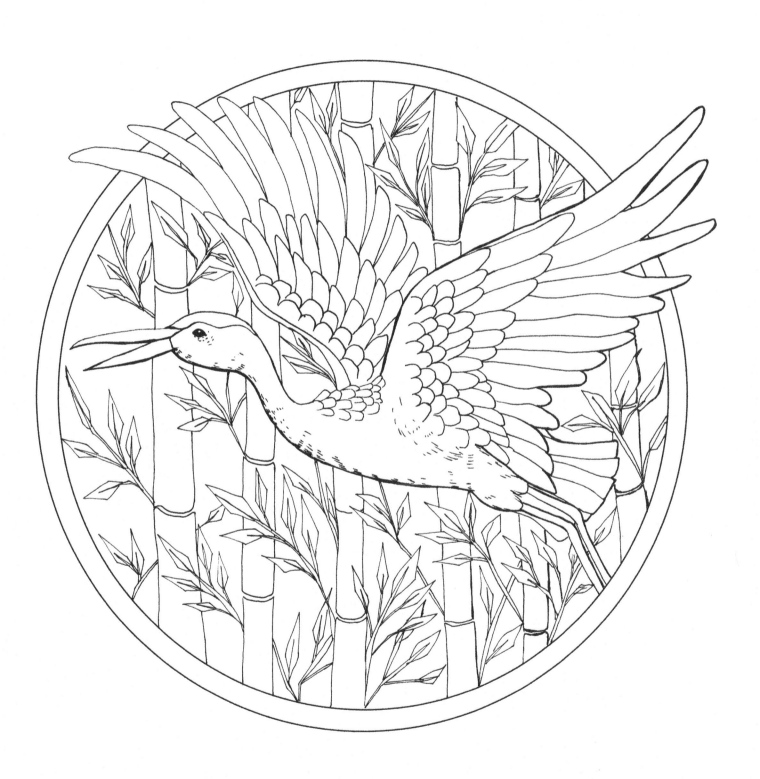

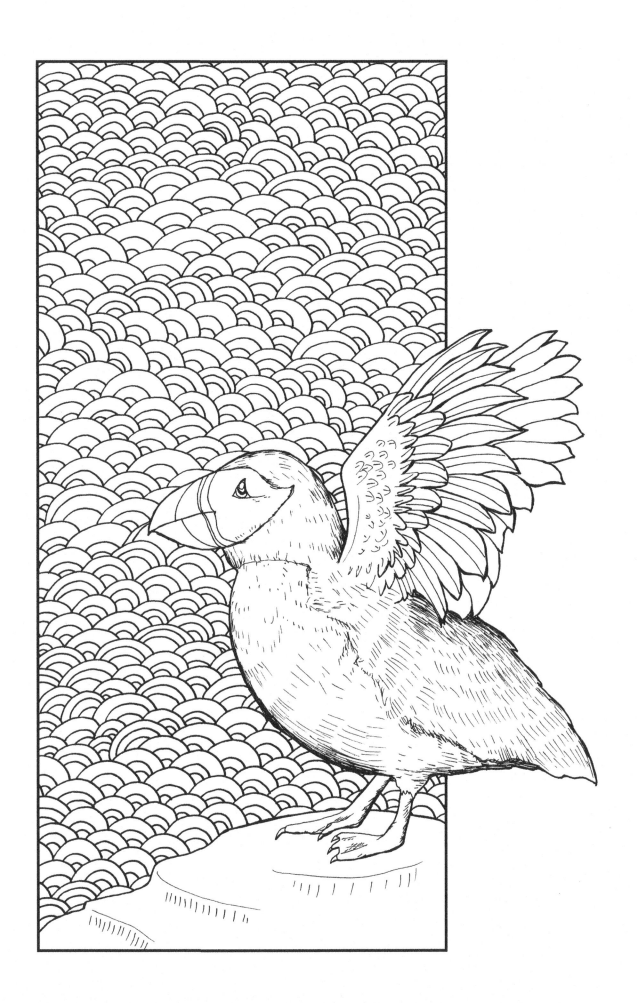

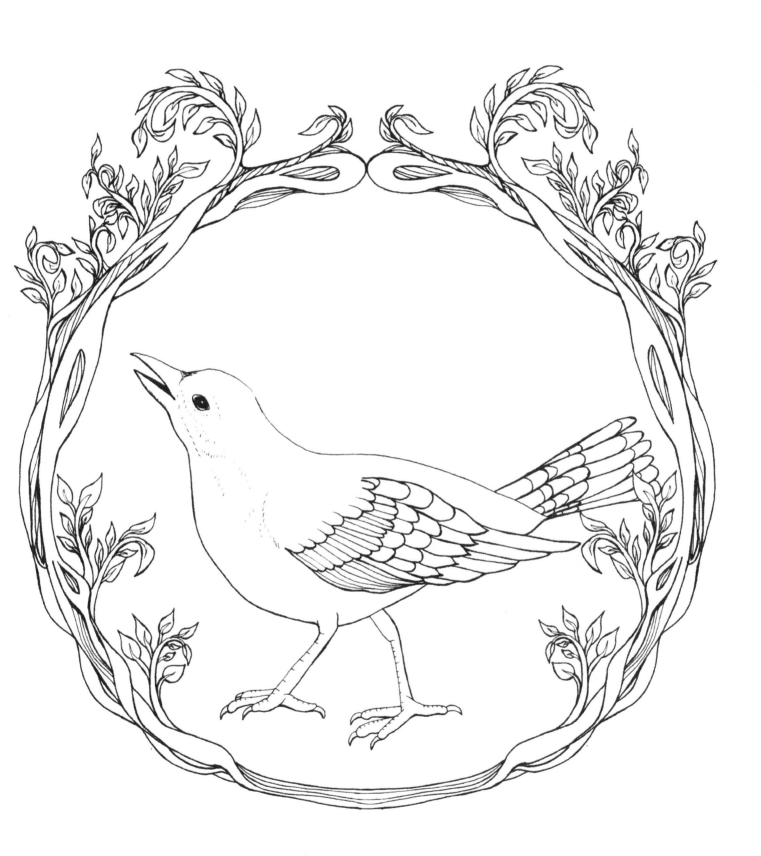

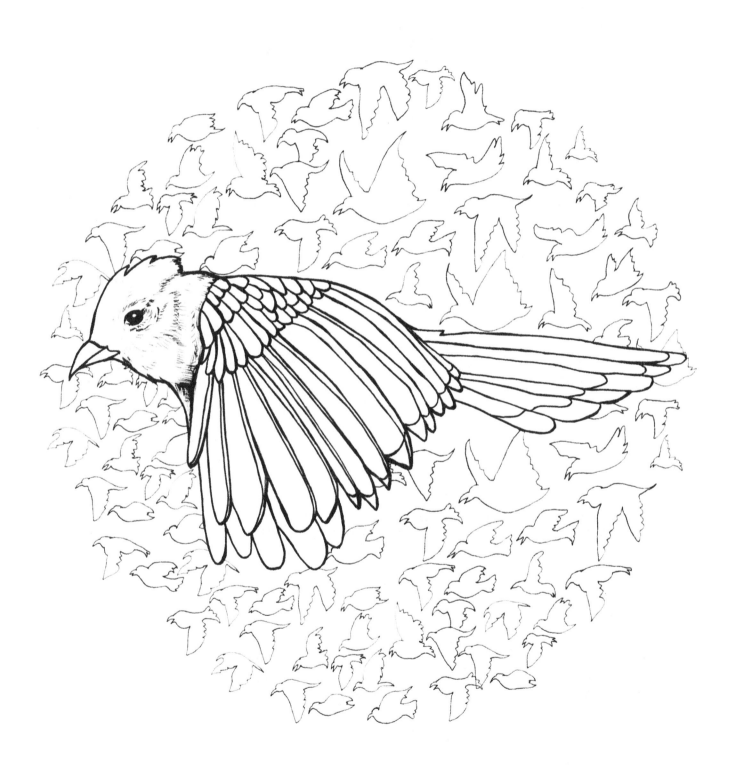

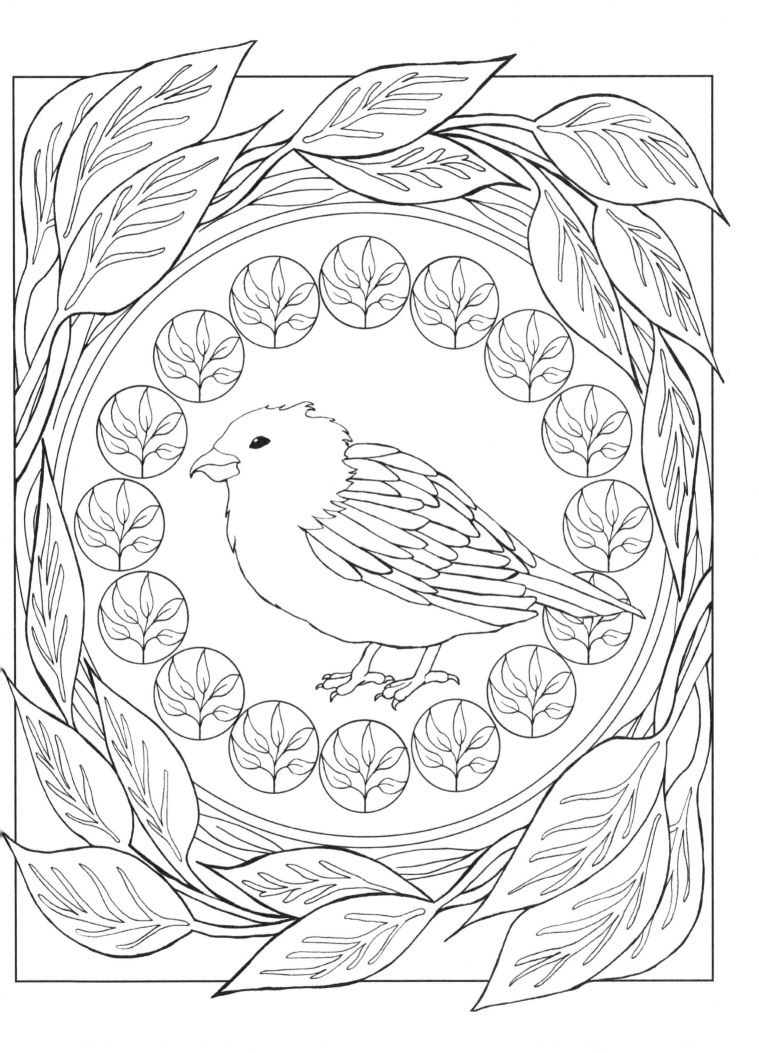

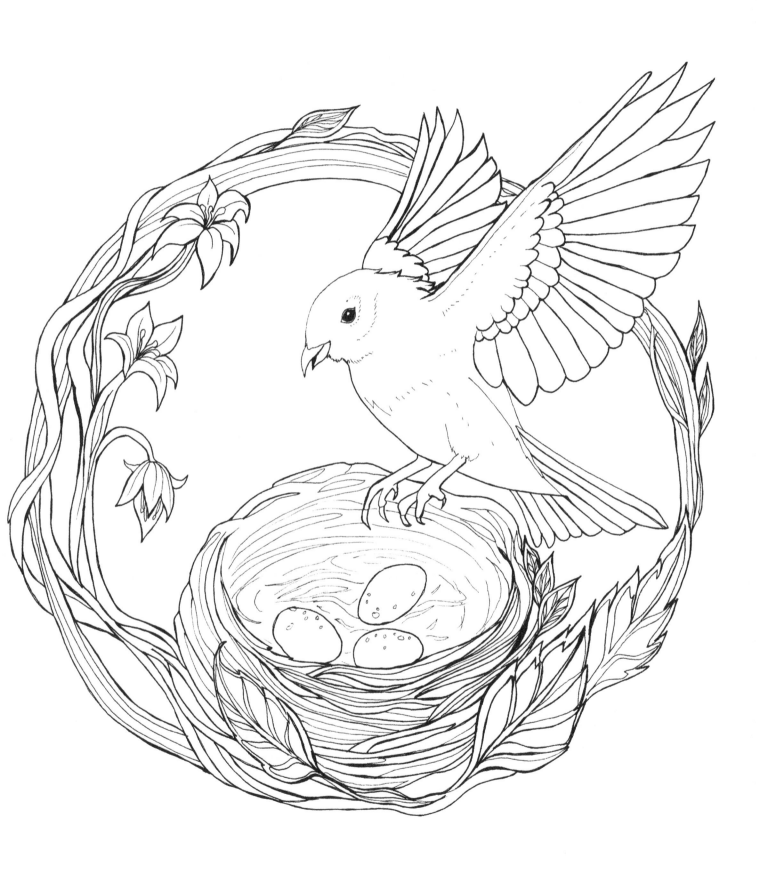

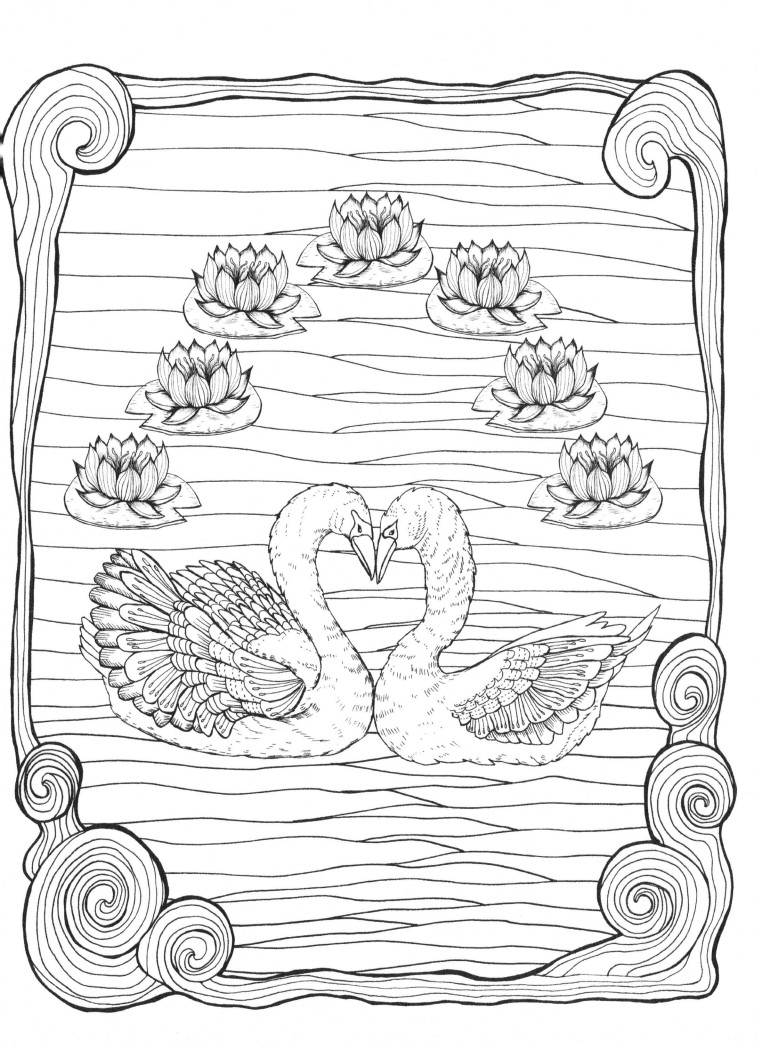

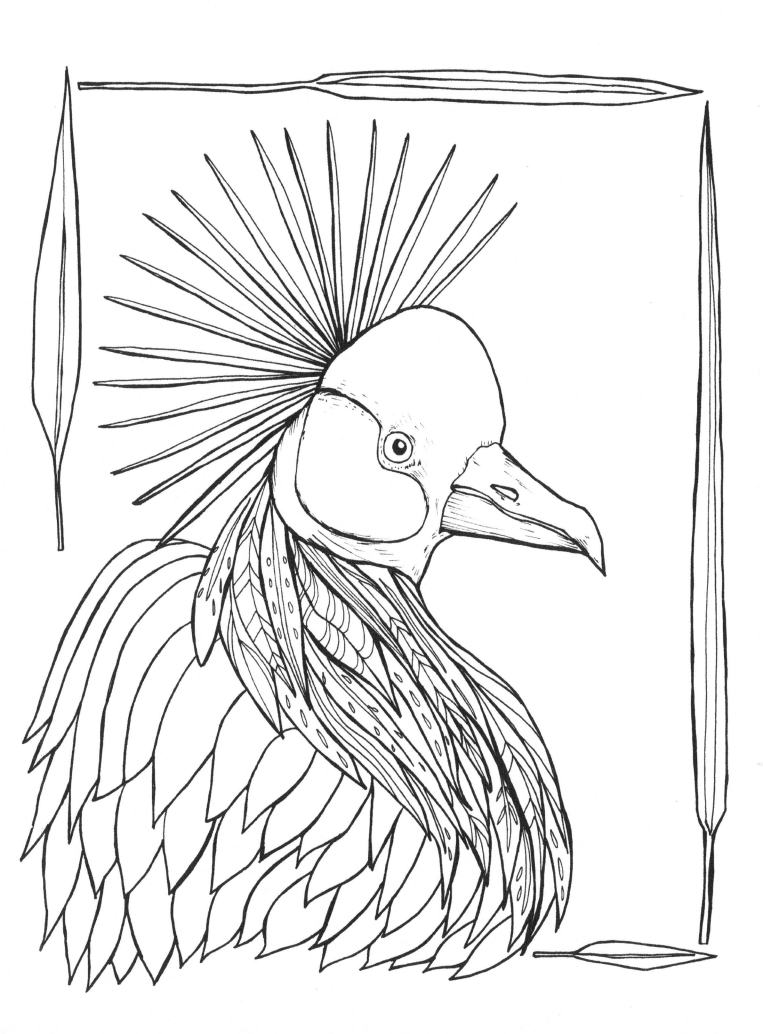

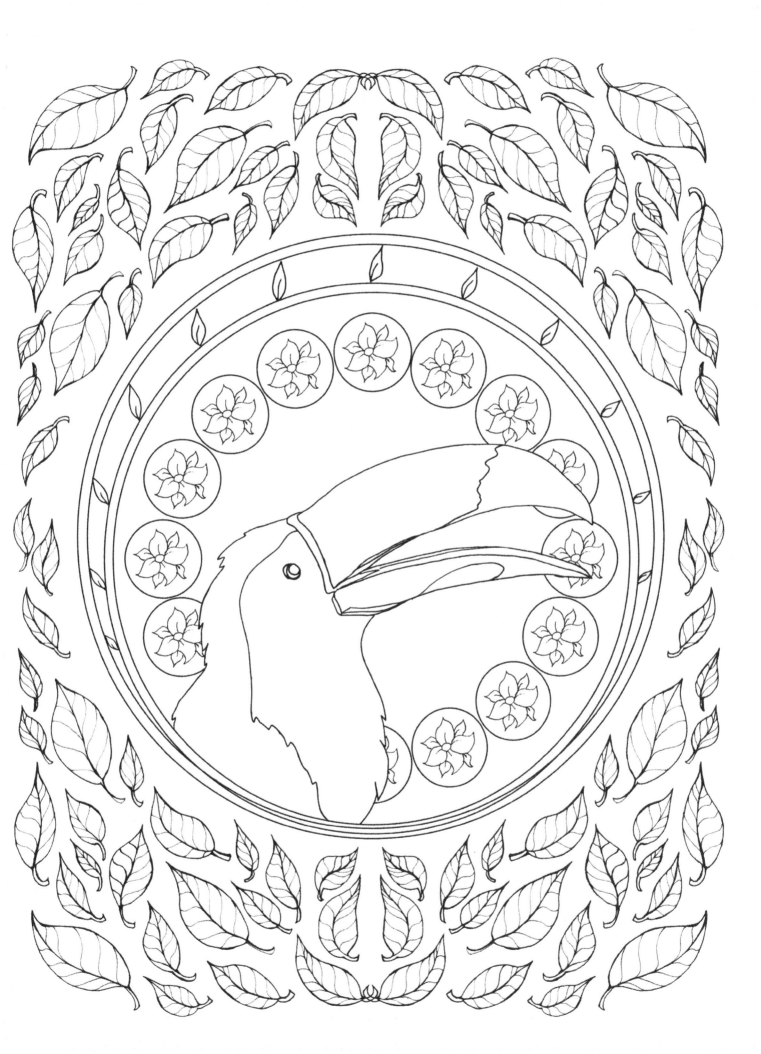

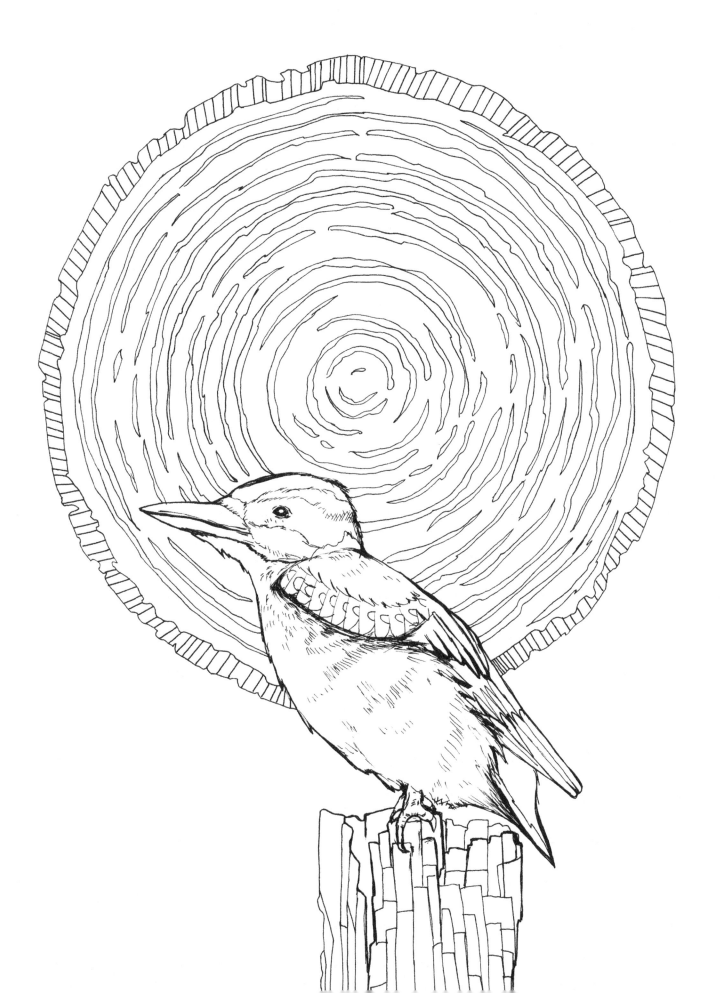

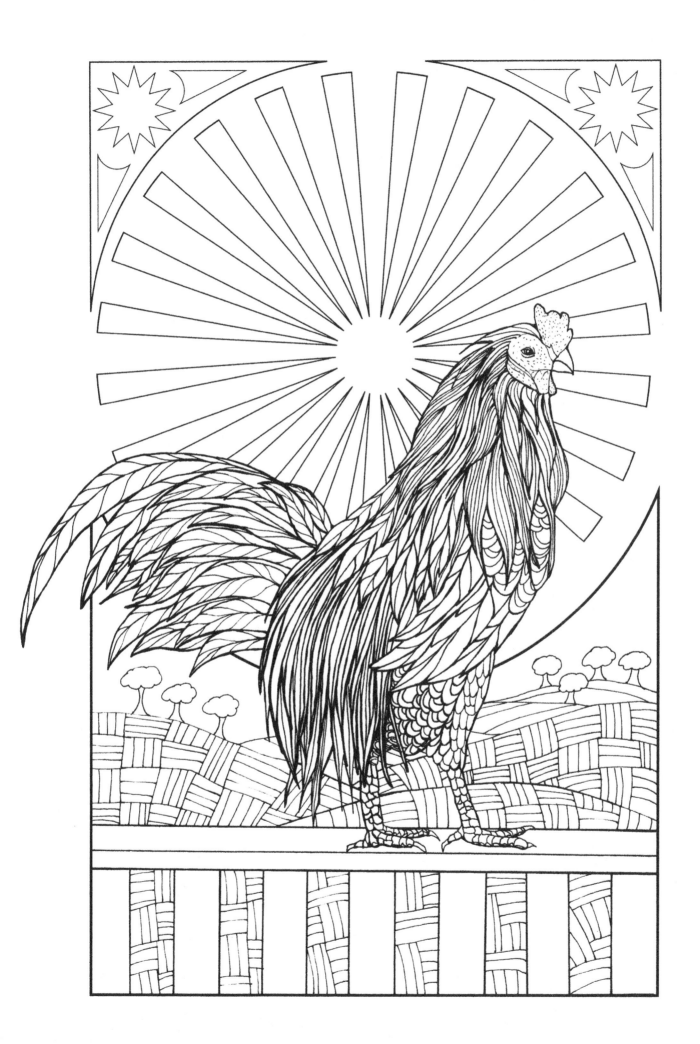

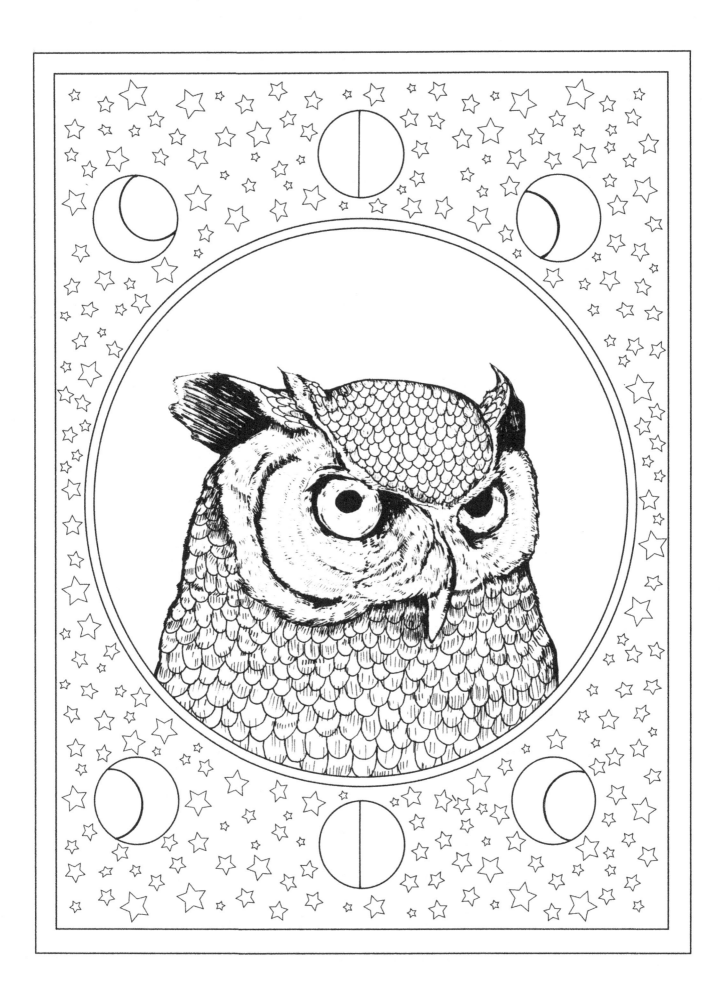

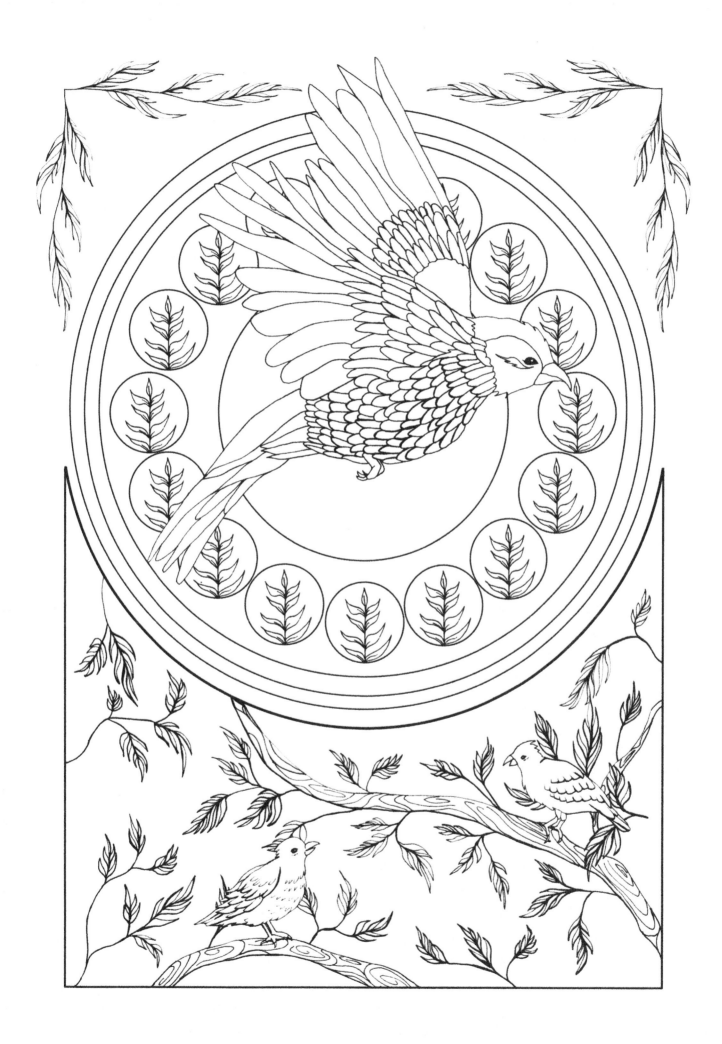

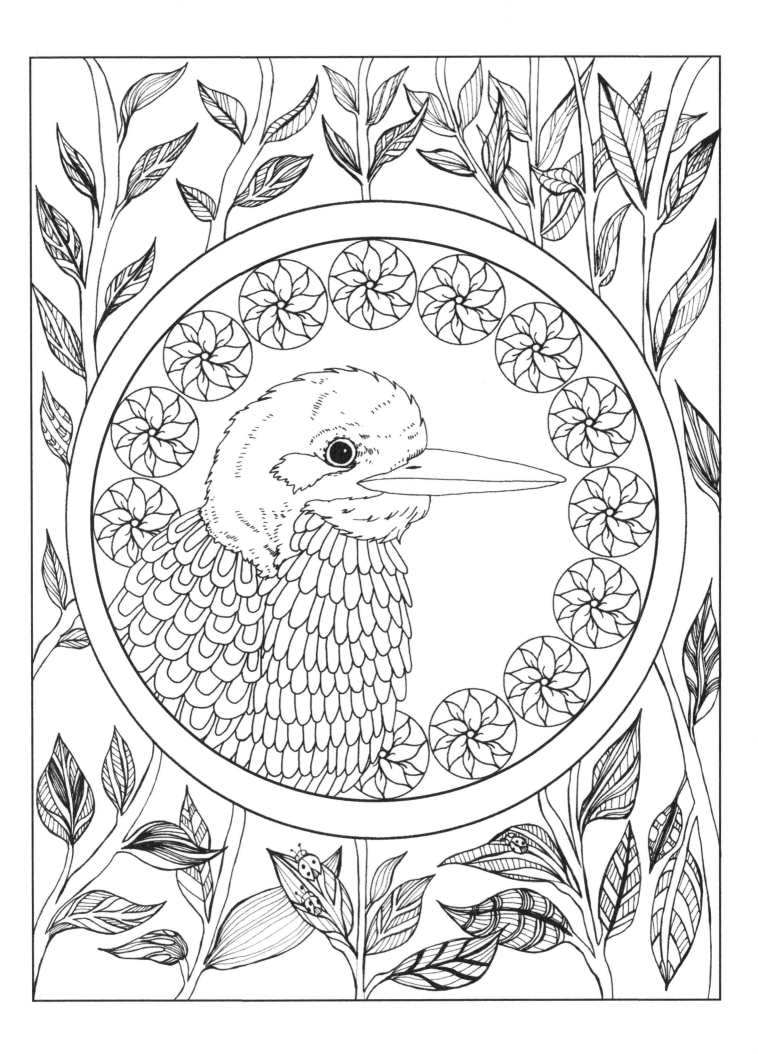

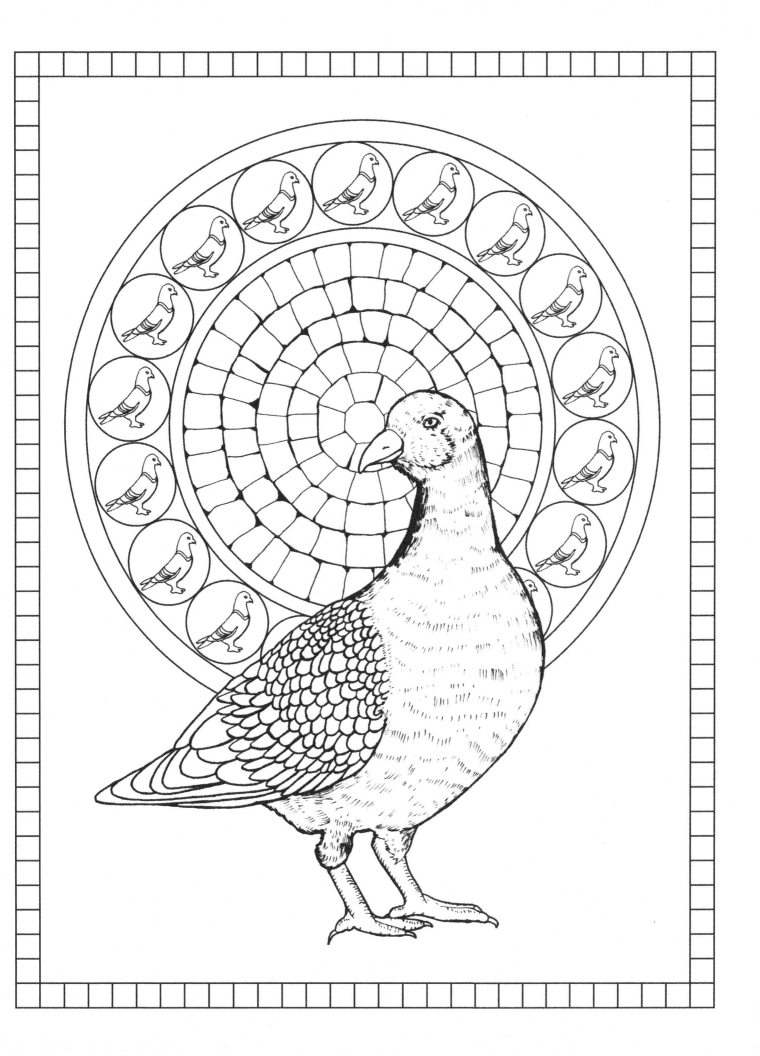

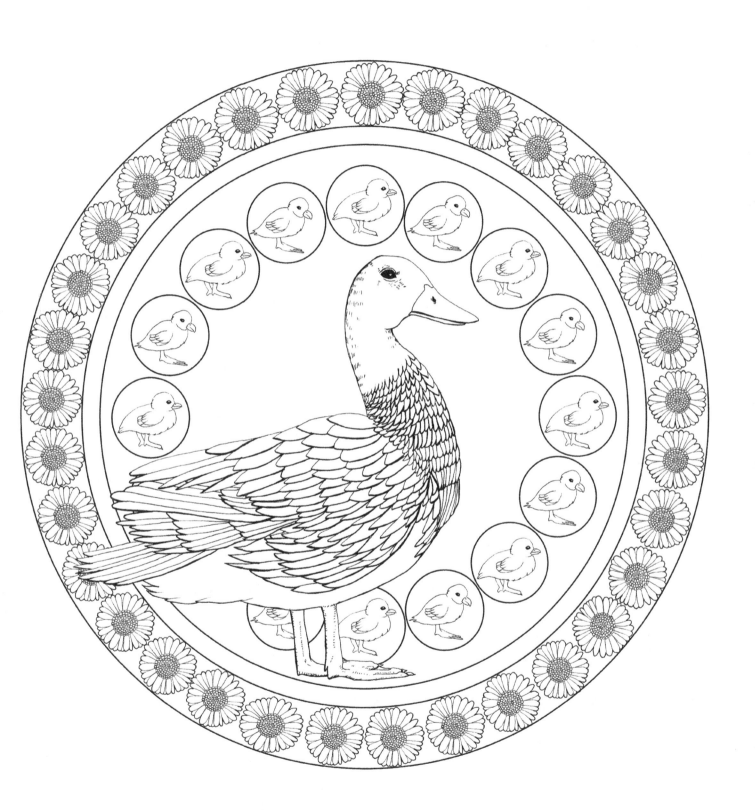

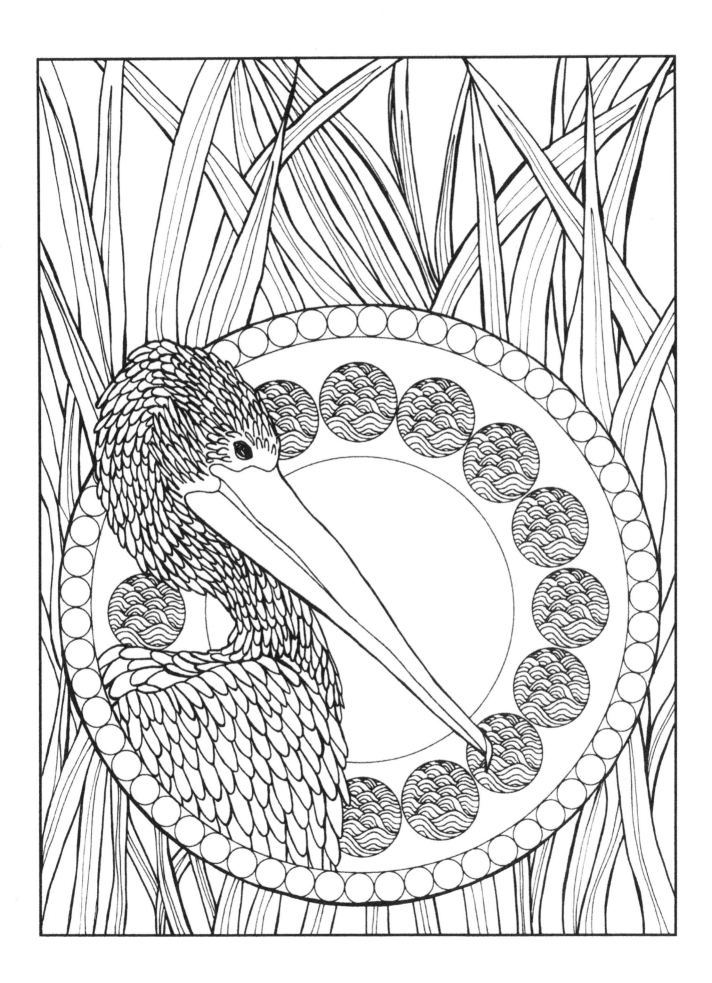

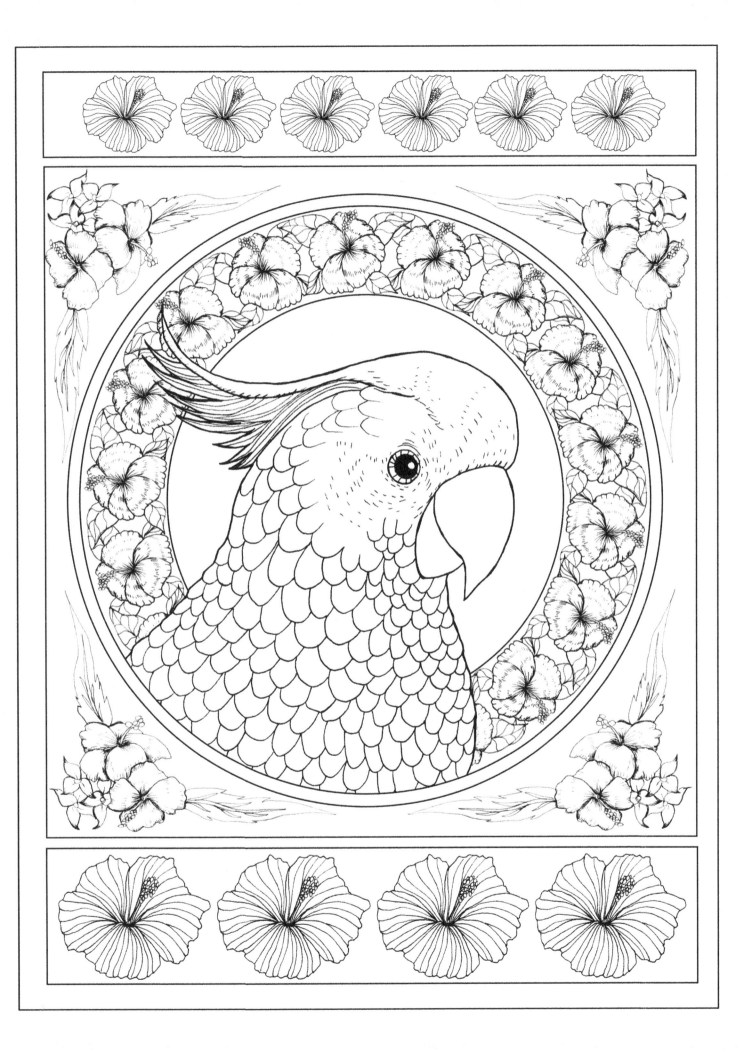

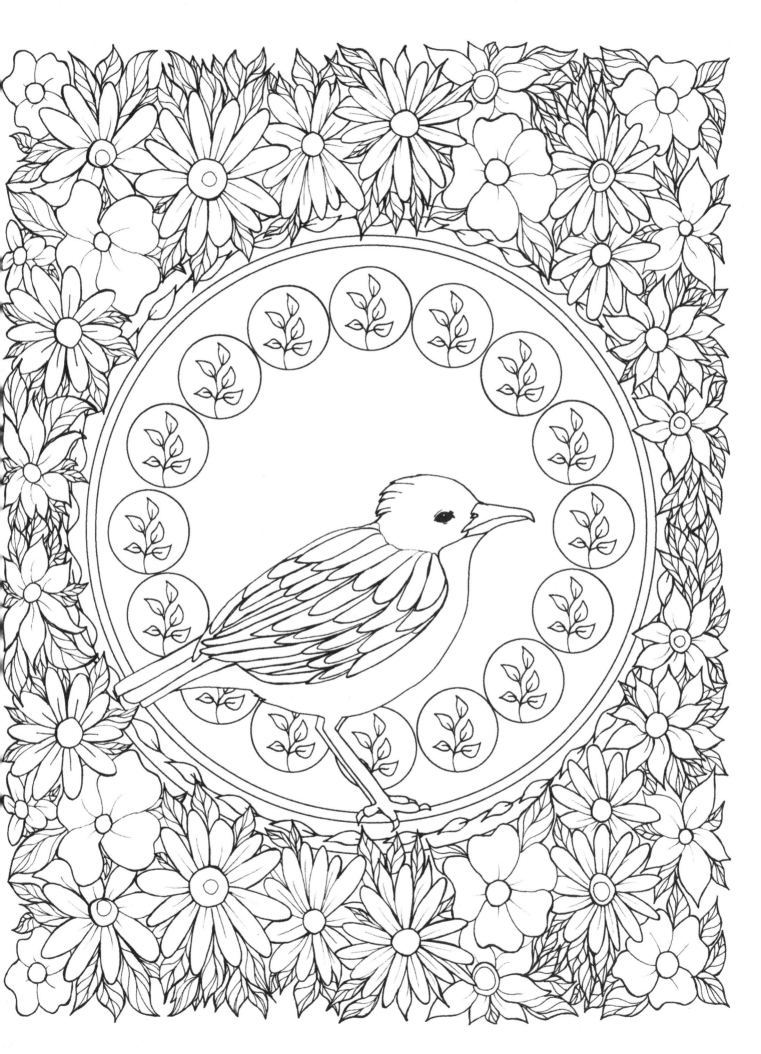

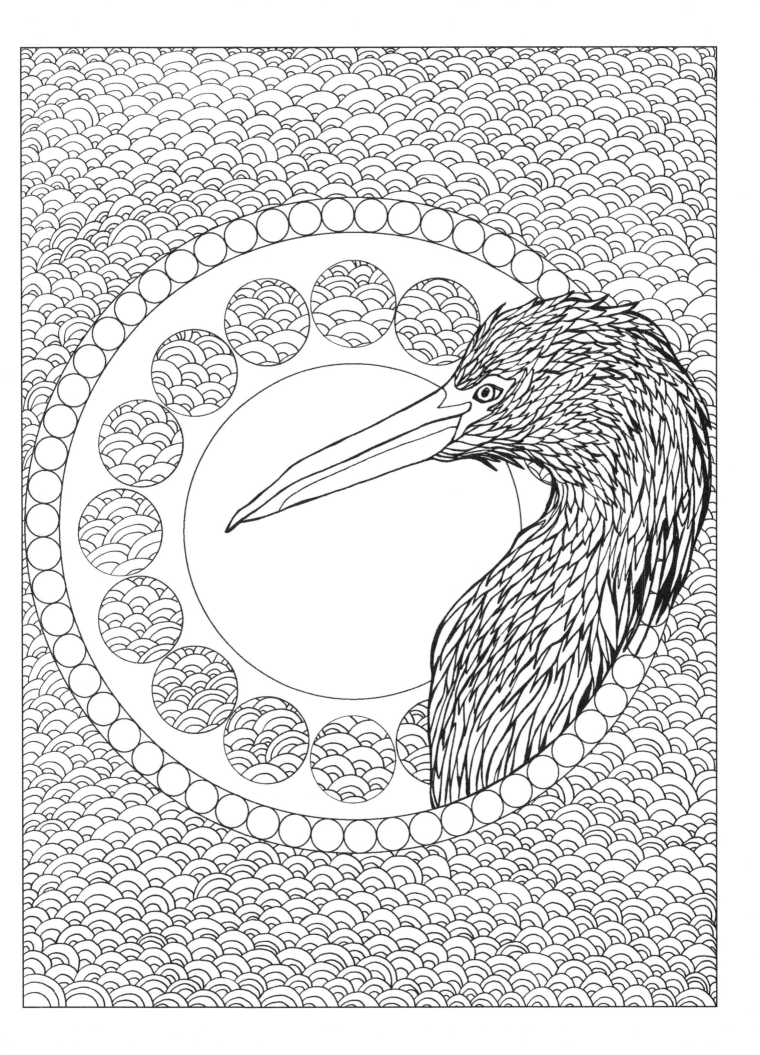

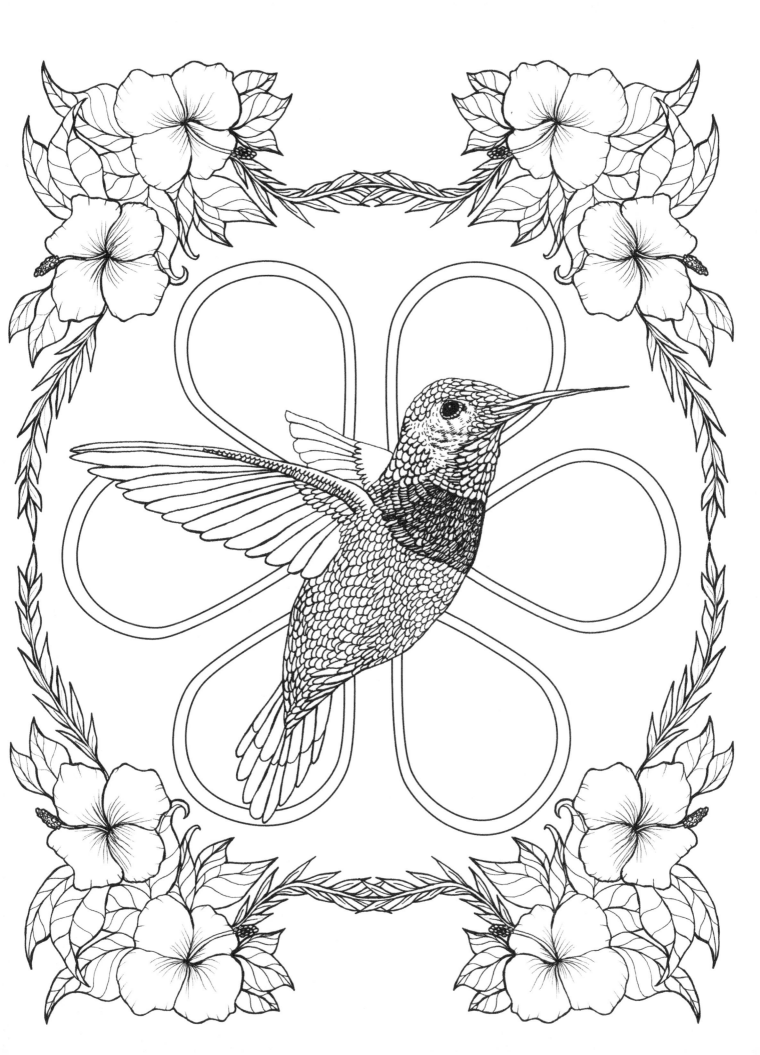

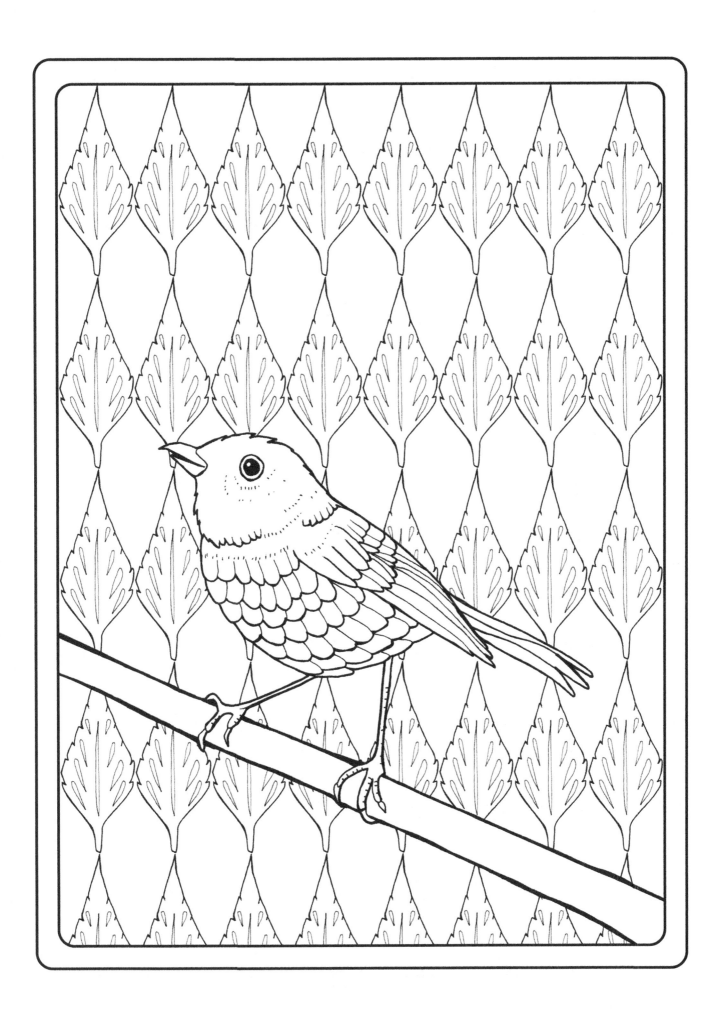

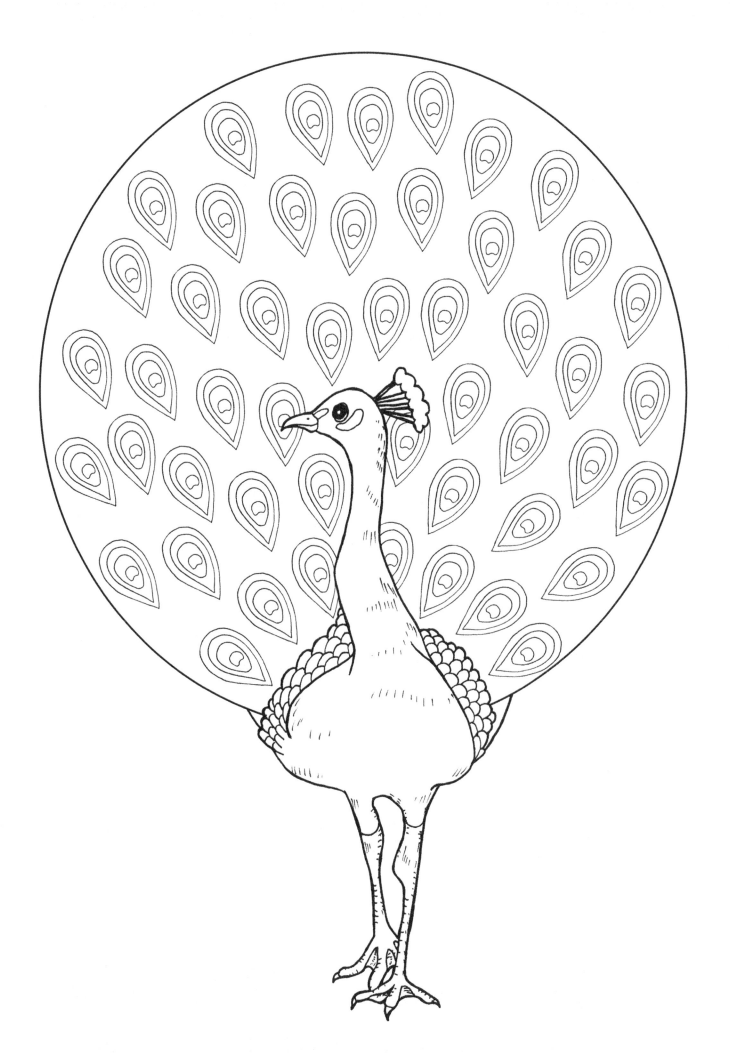

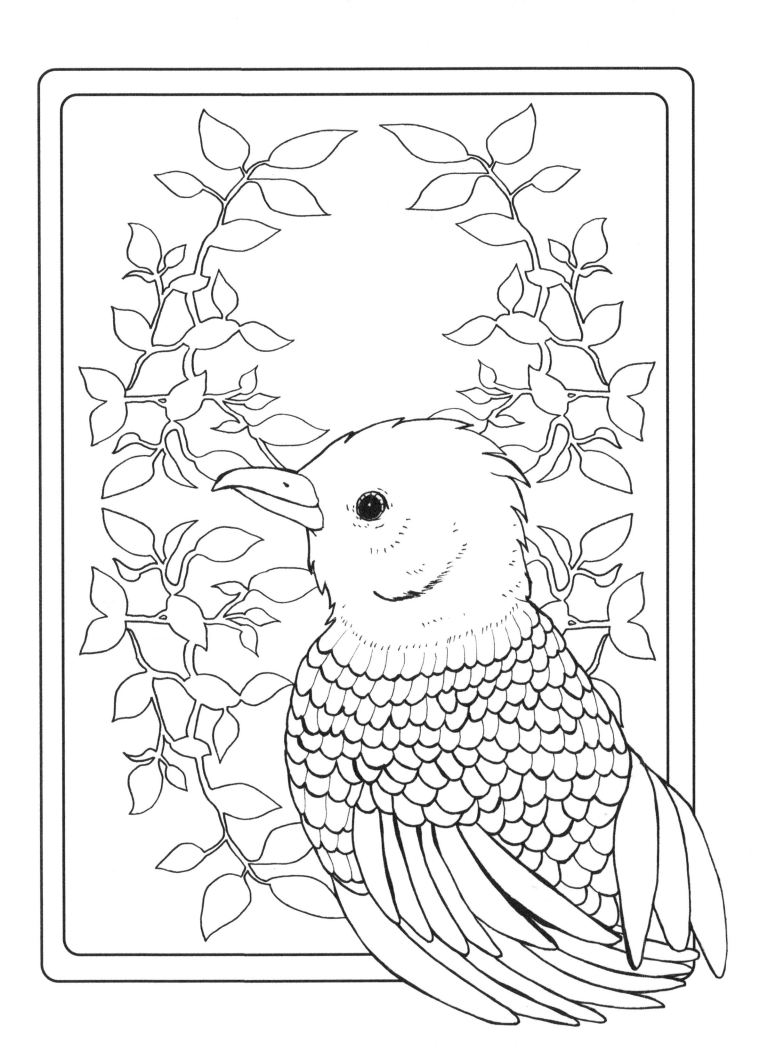

Bonus Images!

The following images are birds from other
Blue Star Coloring books. We hope you enjoy!

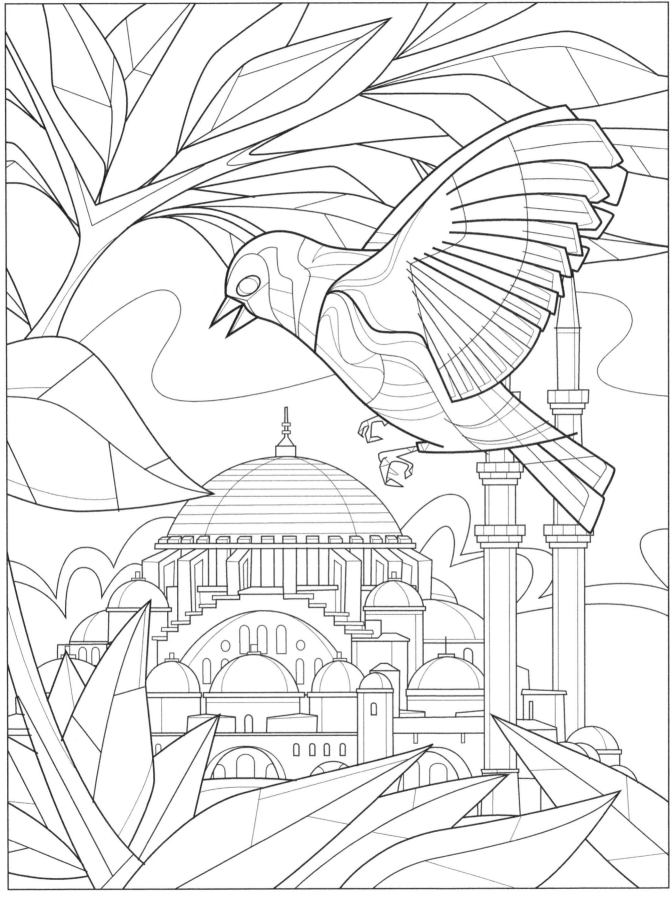

Birds of the World
by Rémy Simard

bluestarcoloring.com

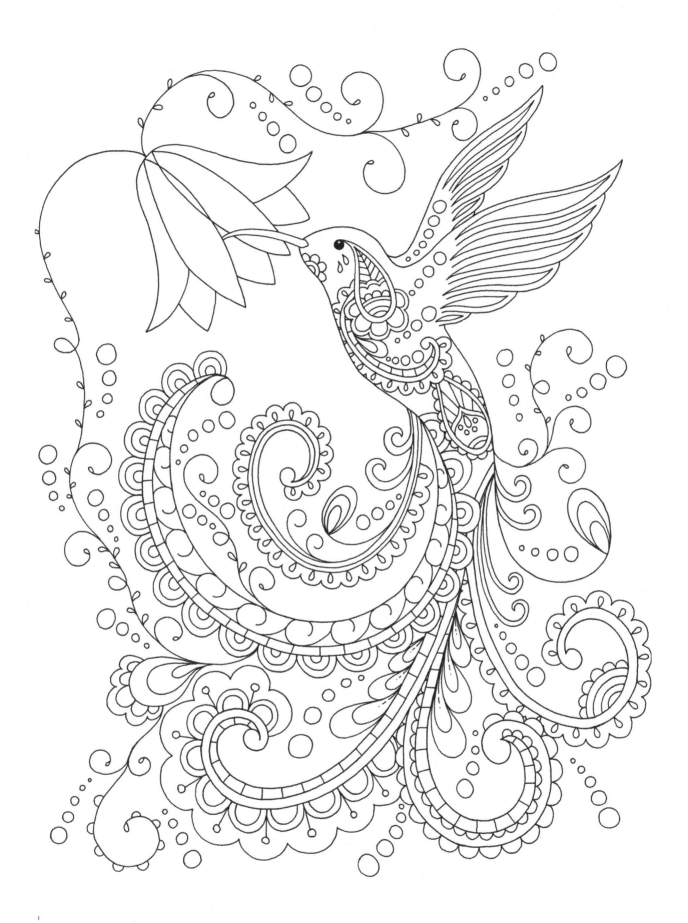

Exotic Animal Designs
by Katie Packer

bluestarcoloring.com

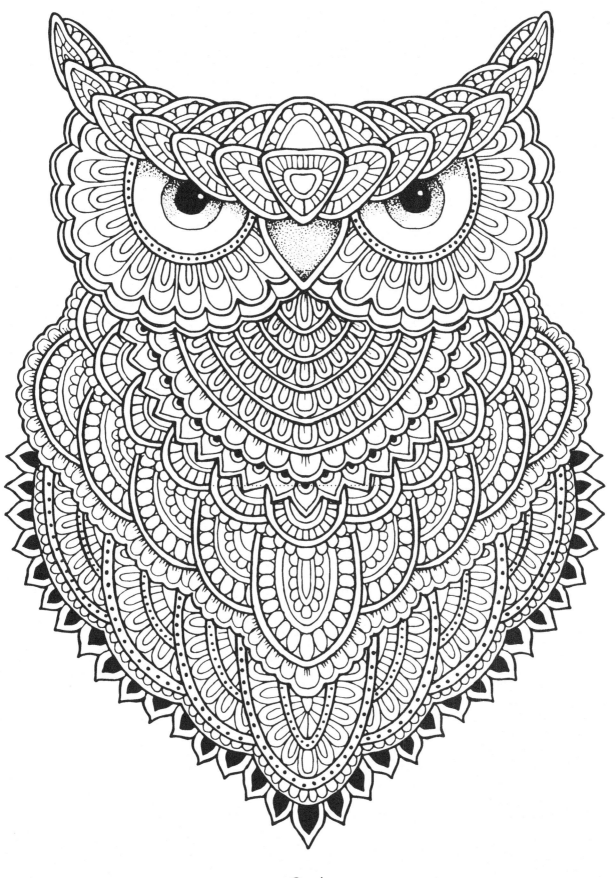

Owl

for Blue Star Inspire
by Jaimie Horan

bluestarinspire.com

Maysa Sem

Kentucky, USA

Maysa Sem is a first-generation Cambodian-American, born and raised in Louisville, Kentucky. She received a BFA in Design from the Memphis College of Art in 2014. Using drawing as a form of meditation, Maysa develops harmonious motifs of nature inspired by the Art Nouveau style. She believes the beauty of the natural world has a lot to offer the human spirit, and she hopes that it inspires others to treasure the details.

Art Nouveau Birds is her first Blue Star Coloring book.

● ● ●

@maysasem maysasem.com

Just a reminder: Maysa is an independent artist, meaning that her opinions and artistic expressions are hers, and not necessarily Blue Star's.

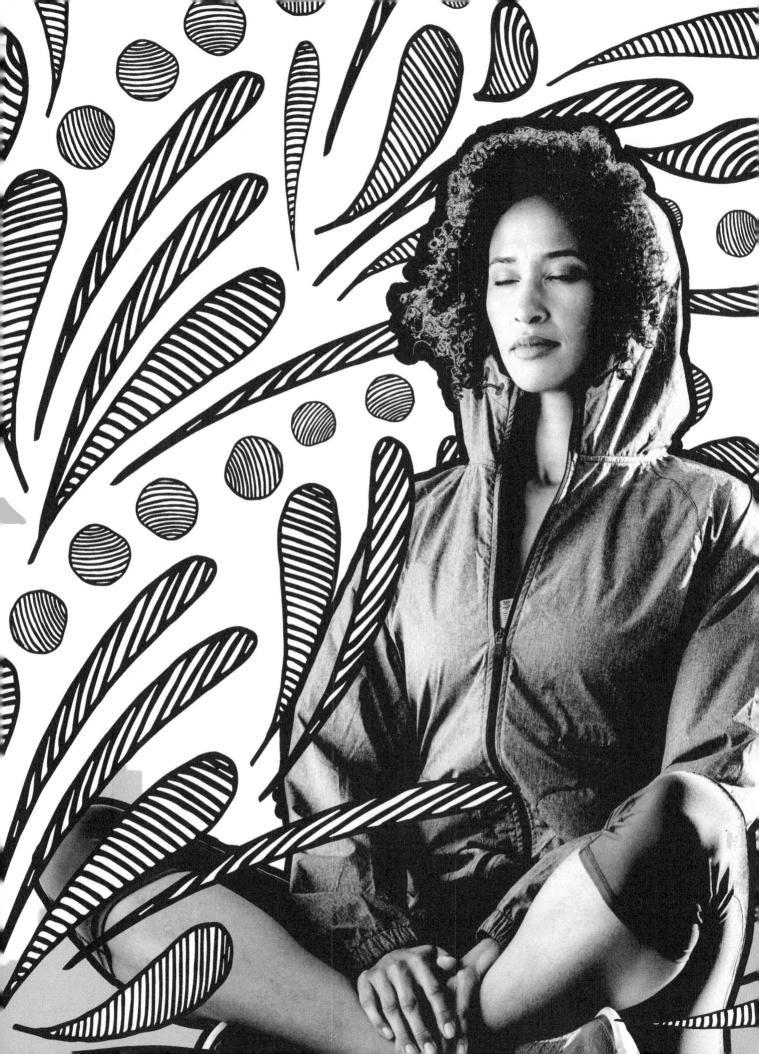

Find Your Calm with Blue Star Coloring + Spire

Discover the mindfulness + activity tracker that helps you be calm – everywhere you go. Blue Star Coloring and Spire have partnered to bring you tranquility in all facets of life. Use Spire to track your state of mind – and when things get a little tense, pick up a Blue Star Coloring book to wind down, refocus, and bring energy back into your day.

Blue Star
bluestarcoloring.com

Made in the USA
Coppell, TX
27 March 2023

14817030R00050